How to Make a Cartoon

M. Usman

Entrepreneur Series

Mendon Cottage Books

JD-Biz Publishing

**Download Free Books!
http://MendonCottageBooks.com**

All Rights Reserved.

No part of this publication may be reproduced in any form or by any means, including scanning, photocopying, or otherwise without prior written permission from JD-Biz Corp Copyright © 2015

All Images Licensed by Fotolia and 123RF.

[Entrepreneur Book Series](#)

Our books are available at

1. [Amazon.com](#)
2. [Barnes and Noble](#)
3. [Itunes](#)
4. [Kobo](#)
5. [Smashwords](#)
6. [Google Play Books](#)

Table of Contents

Preface .. 6
Chapter # 1: Creating Cartoon Characters ... 7
 Have an Idea of How the Character Will Look 7
 Draw It .. 7
 Don't Ignore Colors .. 8
 Give it a Personality .. 8
 Give it a Background .. 8
 Get Feedback ... 9
 Revise .. 9
Chapter # 2: Writing for Your Animation .. 10
 Define Your Objective .. 10
 Write a Storyboard .. 11
 Write a Script .. 11
 Tips to Enhance Your Story .. 12
 Your Characters Must Overcome Impossible Challenges – ... 12
 Emphasize Emotions ... 12
Chapter # 3: Understanding Your Audience 13
 Knowing audiences previous knowledge 13
 You Will Know What Language to Use 14
 You Will Know What Style They Prefer 14
 You Will Understand How to Reach Them 14
Chapter # 4: Tools You Will Need to Make Cartoons 16
 Computer ... 16
 Tablet ... 16
 Microphones .. 17
 Speakers .. 17
 Software .. 17
Chapter # 5: Methods of Creating Cartoons 18
 2D Cartoons .. 18
 3D Animation ... 19

Chapter # 6: Softwares to Use When Making Cartoons 21
Maya ... 21
Blender ... 22
Adobe Flash .. 22
Anime Studio .. 22
CreaToon .. 23
Chapter # 7: An Introduction to Sound Effects 24
It Reinforces Emotions .. 24
Sounds Draw Attention ... 25
Create Anticipation ... 25
Sounds Make Your Movie Come to Life 25
Where to Get Sounds .. 26
Chapter # 8: Recording Voices for Your Animation 27
Choose a Room ... 27
Have a Good Mic .. 27
Have Recording Software ... 28
Use a Pop Shield ... 28
Have Headphones ... 28
Stand up When Recording .. 28
Put the Script on a Stable Surface ... 28
Voice Must Match Lip Movements ... 28
Chapter # 9: Promoting Your Cartoons .. 30
Have a Website .. 30
Don't Ignore Social Networking .. 31
Submit to Local TV stations – ... 31
Have a Stunning Trailer .. 31
Ask People to Share Your Cartoon .. 32
Chapter # 10: Making a Living as a Cartoon Maker 33
Aim High ... 34
Perfect Your Skills .. 34
Make Demos ... 34

 Read and Learn .. 34
Conclusion ... 35
Author Bio .. 36
Publisher .. 47

Preface

You definitely have some cartoons you enjoy watching. And you surely have thought of making such cartoons yourself. The imagination of bringing lifeless characters to life is fascinating, and so is the idea of creating worlds you can only explore in your dreams.

Producing all this, however, may seem like an impossible task. You can tell that you will need to make huge investments just to get started. Fortunately, this is not the case anymore. Advancements in technology have made the process of making cartoons easy. A computer and some special softwares are all you need to get your feet in the industry.

In this book, I will show you how you can make cartons without breaking the bank. You will find tips on creating characters, promotion, recording voices, and more.

I'm sure you will like the book. Enjoy the reading.

Chapter # 1: Creating Cartoon Characters

You probably know a couple of cartoon characters from childhood. The popular ones include Mickey Mouse, Spongebob, Bugs Bunny, Scooby Doo, and others. However, as simple as these characters may look, what hides behind them are days of continuous development.

The same goes for you; if you want to create a great character, know that it will take time.

But you have no reason to worry. This chapter will make it easy. With a little imagination, you can end up with something that can't be erased from people's memories. Let's look at what you must do:

Have an Idea of How the Character Will Look – Before you bring out your pencil and a paper, figure out what kind of a character you want. Is it a mouse? A Zebra? Or an alien? I'm sure you get the idea. Having this figured out makes the process of creating your own cartoon easier.

Draw It – Once you have an idea of what you want to make, draw your

character. To make it stand out, exaggerate its appearance (it's how cartoons are anyway). For example, if you want to portray a strong character, make its biceps, triceps, and shoulders three times bigger than normal.

In case you had trouble in step 1 and couldn't come up with anything, think of a cartoon you know and draw it. Start modifying some of its features. You can add square shaped eyes, change its color, give it big ears, etc. By doing this, you will likely end up with something original.

Don't Ignore Colors – The color you use can determine how people will perceive your cartoon. For example, black, gray, or purple may represent characters that are bad. On the other hand, white, yellow, or pink may show innocence, kindness, and other good characteristics. So choose your colors carefully.

Give it a Personality – Your cartoon needs to have a personality that people can relate to. Most beginners, unknowingly, make their characters perfect. Unless you want to bore your viewers, give your character strengths and weaknesses. So even if it is nice, you must give it bad traits (you can make it be mean, for example).

If you are finding this hard, think of people you know. Assess their strengths as well as their weaknesses. See if you can apply this personality to your character.

Give it a Background – Nothing just starts to exist, everything has a beginning. So do the same with your character; make it have a background. It may be that it came from Mars, it is addicted to chocolate milk, etc.

Character development is really important if you want to engage your audience.

Get Feedback – Once you are done with your character, ask people to give you their opinion on it. Try to find out what comes to their mind when they see it. From their feedback, you will be able to tell if it will be a good fit in your story.

Revise – You will not have a perfect character in a single day. So you must focus on making it better through lots of revisions. Remove features you don't need and add what you believe will improve its look. Will 3 legs make it look scarier? Or will bigger ears make it more attractive. It's only when you are not afraid to revise that you will see it transform positively.

Chapter # 2: Writing for Your Animation

Before you can start producing your cartoon, you will need to do some writing first. The importance of this process cannot be overstated if you are working with other people. Writing your ideas gives everyone involved a picture of what it is you are looking for.

But even when you are working alone, the documents you produce before you begin production are still important.

So let's see how you can tackle this important aspect of animation:

Define Your Objective

Since you want to make a cartoon, the assumption is that you have something worth communicating to your audience. Do you want to entertain them? Do you want to educate them? Or is there something else you would like to achieve in the end?

It is important that you define the objective clearly as this is the basis of your whole story. If you are stuck for ideas, read some fiction books. You

may also watch a movie for inspiration. In addition to that, you can observe your surrounding just to see how people live. There are cartoon ideas almost everywhere. You just need to get your antenna up to pick them out.

Write a Storyboard

Once you have identified the main theme of your cartoon, the next step is to create a storyboard. In essence, this is a series of drawings that tell the whole story in your cartoon.

A storyboard doesn't need to be detailed. As long as it gives an idea of what is happening in each scene, you are good to go to the next stage.

Write a Script

Unlike the storyboard, the script details what happens in each scene. If you are beginning a new scene, you must create a new script for it.

A script has a title of the scene which can be as simple as "Scene 1." It also has a description that explains everything that happened at the scene. If there is dialogue in your cartoon, it must also be included in the script.

You can also incorporate shooting angles, sound effects, and other things. But this will apply mainly when you are working with others.

Depending on the duration of your cartoon, the script can be of any length. So feel free to make it as long as you see fit.

Tips to Enhance Your Story

By getting to this part, you surely know how you can write for your cartoon. To make your story even better, consider adding these tips.

Your Characters Must Overcome Impossible Challenges – If you have been watching movies for a long time, then you know how good it feels when your favorite character overcomes an impossible challenge. With that, I urge you to use your imagination and stack all odds against your character. Use your creativity to make it excel in the end (but this will not apply to all cartoons).

Emphasize Emotions – If there is a point in your cartoon where the characters cries, falls in love, or do something emotional, make sure you emphasize it. However, you will need to get really creative with this. If you developed your character right, your audience should be moved.

Chapter # 3: Understanding Your Audience

As much as you would like your cartoon to be enjoyed by everyone, you must know that it's impossible to achieve that. People have different tastes; what makes you laugh will do nothing to someone else. With that made clear, you must ensure that you make your cartoons for a specific segment of people.

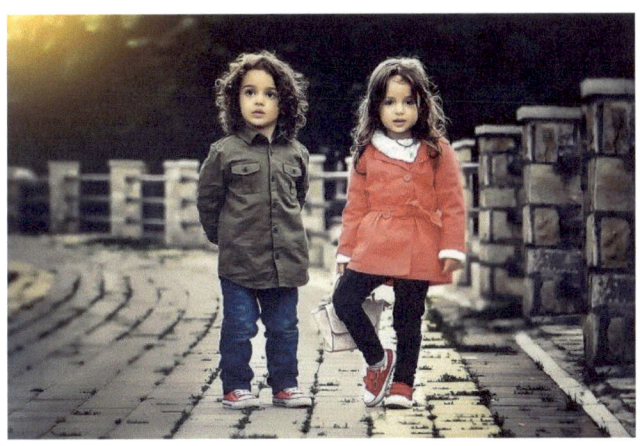

You can say "this cartoon is targeted at children who are 5-10 years old." Although this is segmentation, it is not enough. You must ask yourself whether these children are male or female, where they live, what they like, etc.

Here are some of the reasons why you must understand who your audience is:

Knowing audiences previous knowledge – Since you are making a cartoon with the aim of communicating to people about something, you first need to understand what your audience already knows about the topic. For example, if you are trying to inform them, you do not

what to make your animation longer by including things they already know. Or they will find it boring and move to something else. Knowing their previous knowledge will enable you to include only what is necessary.

Working on assumptions is not the best way to make cartoons, you need to be 100% sure.

You Will Know What Language to Use – By knowing who your cartoon is targeted at, you will know which language to use. This will make the cartoon understandable to your audience. You must not think that because you know the meaning of certain words, then everybody will understand them.

You Will Know What Style They Prefer – Every individual has a specific style of cartoons they like. So if you let your mind do the judging, you will make something that is palatable to you and not your audience. And that will spell doom for your animation.

So do a bit of research on your audience and determine what form of cartoons they prefer.

You Will Understand How to Reach Them – Making a great cartoon is not easy. However, no matter how good your animation is, if it does not reach your audience, then you have wasted your time making it.

By understanding who your viewers are, you will know the best way to reach them. Should it be social media? Or trailers on your local TV?

Additionally, you will also shape your promotional message so that it's effective to your audience. If your message is designed to reach everyone who watches TV, you will likely fail to promote your cartoon. And you will risk going bankrupt in the process.

Once you have identified your targeted viewer, keep his picture on your wall as you will be making your cartoon. As crazy as this sounds, it helps. When you start going off track, a look at your persona is all your need to get back on the right route.

Chapter # 4: Tools You Will Need to Make Cartoons

If you want to make cartoons, you will need to have some tools. Depending on what type of a cartoon you want to make, these tools will differ to some extent. In this chapter, I will give you the basics of what you need.

Computer – Computers are being used in the production of just about everything these days, cartoons are no exception. If you are making simple cartoons in 2D, a computer costing less than $1000 will do. But still, it needs to have some decent specs to run efficiently. If you are going for 3D, on the other hand, you will need some serious piece of equipment. It is not strange to be looking at computers costing more than $1000.

Tablet – Since you will not draw on your monitor with a pencil, you will need to have a tablet to draw your characters on. Using a mouse to draw characters is not easy. So do yourself a favor and get a tablet. Anything in the region of $100 dollars should be adequate.

Microphones – Your computer probably has a mic, unfortunately, that is only good for Skype calls as it will not cut it for recording voices. So get yourself a good mic. And since most mics will not connect to your a computer, you may also need to get a mixer. It does not need to be big or expensive. Just something that will get the job done.

Speakers – These are another important piece of hardware you must have. Cheap studio monitors will be just fine. In addition to this, you must also consider getting a nice pair of headphones.

Software – the whole process of making a cartoon will be possible with the right software. We will talk about this in detail in the following chapters.

Chapter # 5: Methods of Creating Cartoons

When making cartoons, you have a choice between 2D and 3D. What you go with largely depends on your needs. 3D looks more impressive than 2D, but that does not mean the former is better. I have seen 2D cartoons that are far more fascinating than those in 3D. It is just a matter of using your creativity to make a perfect story that will grab your viewer's attention.

So let's look at these two:

2D Cartoons

For decades, this has been the norm. Actually, the majority of cartoons you grew up watching were in 2D. So what does it mean?

2D stands for two dimensions: height and width. This means you do not get to see depth. An example of a cartoon that's in 2D is The Simpsons.

When making a 2D animation, you produce a series of drawings and each is slightly different in pose. When these are put together, they create an illusion of movement.

In the past, 2D animation was made in what was known as cel animation. The characters were drawn on a cel first, then their photographs were taken and combined.

If you think this was a lot of work, you are right. And it also took a lot of time. But with an improvement in technology, 2D animation is now made with computer softwares.

The biggest problem with 2D animation is that if you want to move the camera angle, you will have to make another drawing. This can be very time-consuming.

The biggest benefit with 2D animation is that you do not need super powerful hardware, so you can save money whilst perfecting your cartoon making skills.

3D Animation

3D animation hasn't been around for a long time although the concept of 3D is very old. In this, your characters exist in a 3 dimensional world. You can see height, width, and depth. The end results are cartoons that can, sometimes, look life-like.

Objects in 3D animation are treated in the same way you would treat objects in a real world. If you want to move the camera, you can do it easily. If you

want to change the lighting, you can also do that without much ado. But if this was 2D animation, it means you would have to create new drawings and make the necessary changes.

An example of a cartoon in 3D is Shrek.

Both of these methods are feasible to you. However, for a start, I would suggest that you go with 2D animation. It is much easier to make than with 3D and you do not need to invest in pricey hardware. The introduction of 3D does not mean it is the end for 2D. As you already know, your story is much more important that a perception of depth. So do not worry much about this, just focus on getting your story right because it is what people will remember when the cartoon is over.

Chapter # 6: Softwares to Use When Making Cartoons

You will need a cartoon-making software when creating your animations. Unfortunately, there are a lot of these on the market which is overwhelming for beginners. Considering that these softwares do not come cheap, you will need to get it right the first time. Making the wrong choice will be a waste of time and money.

So without further ado, let's look at these softwares:

Maya

If I would have to choose the best software for making cartoons, I would definitely go for Maya. In fact, even big name cartoon producers use it. If you are creative, you can make stunning 3D cartoons with this software. Maya has everything you would ever ask for.

The only downside, however, is that it is very expensive. For this reason, I would advise you to go for it when you are confident with your cartoon making skills. As a beginner, this is not the best choice.

Blender

Now in case you are disappointed that you couldn't get Maya to make 3D cartoons, you have no reason to worry. You can have Blender. As far as you are looking for simple cartoons, this will do just fine.

Sweetening the deal is that you do not need to pay anything to get this software. However, do not expect to find as many features as in Maya.

Adobe Flash

Adobe Flash is one software that has stood the test of time. It is the most popular 2D animation software you can get. The one thing I like about it is that it is easy to learn and use.

When compared with other softwares, Adobe Flash does not have everything. But it still has enough to be usable by anyone. Even better, it is much cheaper than other cartoon making softwares on the market.

Anime Studio

Finding a software that has a good balance between features and price is not easy in this industry. But the one software that does that is Anime Studio. For all those who are just getting started, this is one software you may want

to look at.

Anime Studio comes with a number of plugins, and this gives it more functionality. At the same time, it is quite affordable. The 2D games you can make in this are also very great.

CreaToon

The name makes it clear that this software is to be used for creating cartoons. The best part with CreaToon is that it comes for free. Unfortunately, it does not have a lot of features to make it a software that you can depend on. But for practicing your skills, it is adequate.

Once you choose the software you want to use, make sure that you learn to use it well. Each software works differently meaning the way you will make cartoons will also differ.

However, remember that these are just tools. Your imagination and creativity are much more important. You can spend thousands on a software, but if you story sucks and your production is flawed, no one will give you a chance, they will not care how much money you put in your cartoon.

So focus on your skills and not softwares.

Chapter # 7: An Introduction to Sound Effects

Ever since we started the book, we have focused on the video aspect of your cartoon. However, one thing you must also pay attention to are the sounds.

You probably have ever watched a movie with the sound so low that you couldn't hear anything. Can you recall if this was a great experience? Did you find the movie interesting? Probably not!

It is important to have sounds in your movie, but at the same time, these must be relevant. If you miss these two important points, your cartoon will be like a house without reinforcements. Sooner or later, it will fall to the ground.

Here is why sound is important:

It Reinforces Emotions – Take any good movie that you enjoy. As you will be watching it, pay attention to the sounds being used. If it's a scene

where a character cries, what sounds do you hear? If it's a scene where the character is happy, what sound is being used? Try to look away from the screen so you can just listen to the movie.

When you are making your cartoon, make sure you use sounds that reinforce emotions. If you just use sounds for the sake of it, you will confuse your viewers.

Sounds Draw Attention – Good cartoon makers know how to use sound to get the attention of the viewer. So if your character is about to say something important, try to use the right sound to notify the viewer that something is about to be said and he should not miss it.

Create Anticipation – When you are watching a movie where something bad is about to happen, you will know it by hearing the sound first. The sound notifies you that the character may be heading in the wrong direction where he will meet his doom. This puts you on the edge of your seat and contributes to the enjoyment of the cartoon.

Sounds Make Your Movie Come to Life – Even though you are just making cartoons, your audience will want it to obey the laws of logic. If you character is in a car, they will want to hear it moving. If someone opens a door, they will want to hear that too. If your character is in a cafe, they will want to hear people talking in the background.

These may seem like little things, but they can make a big difference to your cartoon. If you ignore this, your viewer will have a feeling that something is not right.

Where to Get Sounds

Now that you understand why you need sounds for your cartoon, the next question is where to get these sounds.

You can easily download them online. However, you must first determine if you have the permission to use those sounds in your cartoon. You can also get these sounds by buying CDs.

If you cannot find what you are looking for, then you have to record your own sound effects. We will talk more about recording in the next chapter.

Chapter # 8: Recording Voices for Your Animation

If you have some dialogue in your cartoon, it is important that you record it yourself. Recording voices is not all that difficult. As long as you have the right tools, you will surely cut it. Here is what you must know before you start recording.

Choose a Room – You do not want to have kids screaming in the background in your cartoon. And you surely do not want to have wind blowing when your cartoon is in an office setting, it will confuse people.

So the best way to eliminate unwanted sounds is by making your recordings in a room. This will help minimize outside noise to some degree. So close all doors as well as windows. Since concrete floors can reflect sound, you may need to use a carpet. Additionally, you must also cover the windows with curtains.

Have a Good Mic – As said before, a good mic is worth its weight in gold. Your computer microphone will not do it.

Have Recording Software – Not any software that can record sound will work in this case. Because of this, you must ensure that you are using a decent recording software. There are a lot of these on the market and some are very expensive. But you can get away with something as simple as Audacity which is also free.

Use a Pop Shield – To avoid popping sounds, you will need to invest in a pop shield. But if you do not want to waste money, then you can make it yourself with a wire or a ring and a pantyhose.

Have Headphones – A good pair of headphones that blocks outside noise are instrumental when recording voices. So get one of these. Although these are expensive, you should be able to find something decent for $100-200. If you are trying to save, you can as well buy a used pair of headphones. Just test it thoroughly before you take it home.

Stand up When Recording – When you stand upright, you let in more air into your lungs. This gives you a chance to make them work at full capacity. You will breathe better, which will make you feel energetic. At the same time, you will have better control over your voice.

Put the Script on a Stable Surface – You may be tempted to hold the script in your hands. But that is not recommendable. The paper will make noise as you will be moving which can ruin your recordings. You surely do not want an unnecessary paper sound when there are no papers in your cartoon.

Voice Must Match Lip Movements – Many beginners do not

pay attention to this. But as you will be making your cartoon, you must ensure that their lip movements are in tandem with the voice. Otherwise, you will throw the viewer off track.

Chapter # 9: Promoting Your Cartoons

It is sad to see how some great cartoons get buried under the soil thanks to bad promotion. The thing is that no matter how good your cartoon is, you must find a way to get it in your viewer's face. That is the only way it will become successful. Showing it to your mother or brothers is not enough.

This means you must take your hat of a cartoon maker off, and wear that of a marketer.

If you believe marketing is not for you, you can hire someone to do it on your behalf. Unfortunately, you will need to spend a lot. Adding to that, this other person will not have as much enthusiasm as you have for your cartoon. This is why you must do it yourself.

Here is where to start from:

Have a Website – We now live in the digital age where people expect to find everything they want on the internet. So you must ensure that you have a website to showcase your work. The best part is that making a

website is easy and you can even do it for free. But I recommend that you buy a domain name and hosting, you will look more professional that way.

When making your website, you must ensure that its look is related to the topic of your cartoon.

Don't Ignore Social Networking – If you hate using social networks, you will need to accommodate them for the sake of your cartoon. People are now using these sites more than ever. And if you can use them right, social networks will get your cartoon discovered faster than you can imagine.

So create an account on Facebook, Twitter, Google+ or anything you know will work. Let friends and family become your fans and followers. Ask them to spread the word about your cartoon to their friends.

On your part, you must ensure that you are posting interesting content on your accounts. As time goes, your fan base will grow.

Submit to Local TV stations – Your local TV stations probably have some empty slots they would like to fill with something. So do not be afraid to approach them. If your cartoon is interesting and appropriate for TV, you stand a chance of being given the opportunity to be on TV.

Have a Stunning Trailer – Trailers can make or break a movie. You must ensure that yours captures the attention of your viewers and leaves them wanting to watch the whole cartoon. The trailer must be short and should not reveal everything. Otherwise, people will not find the need to

watch your cartoon (it's not all cartoons that require a trailer).

Ask People to Share Your Cartoon – Most of the times, we are afraid to ask people to do things for us. But if you made them laugh or touched them in some way with your cartoon, people will want to thank you. So asking them to share it with their friends is not such a bad idea.

Chapter # 10: Making a Living as a Cartoon Maker

Can anyone make a living as a cartoon maker? The answer is yes and no! It all depends on how dedicated you are to succeed. Once you are established, you can make a nice living just making cartoons.

If you want, you can make the cartoons for yourself and sell them. Depending on how good you are at this skill, and how good your marketing is, you can make a lot of money this way. If you can keep it for some time, you will even realize that you may need to hire other people to help you.

Apart from that, you can make cartoons for other people. Your clients will give you projects that you must finish according to their requirements.

The best part of working for clients is that you do not have to make big investments to get started. You just need to invest in your skills.

To increase your chances of making it as a freelance cartoon maker, here is what you must do:

Aim High – You need to have goals as a cartoon maker. So decide where you want to be in 2, 3, or 5 years. Dream of making cartoons that will be enjoyed by millions of people around the world. That will prepare your mind to do what it takes to achieve that dream.

Perfect Your Skills – A degree is not necessarily an ingredient for success in the cartoon making industry; your skills are much more important. If you can show your clients that you know how to make cartoons, someone with a degree but can't prove his skills will not hold a candle to you.

Make Demos – This is what clients will see before they hire you. So make your demos as impressive as possible. Try to keep them for longer than 3 minutes.

Read and Learn – You must keep on learning to improve your skills. So get your hands on anything that has to do with making cartoons.

With hard work, you can open a lot of doors and earn a nice living just making cartoons. The keyword here is "hard work." So give this business all you can. You might just land yourself a job at a nice studio like DreamWorks.

Conclusion

Firstly, I would like to congratulate you for getting this far. With everything you read in the book, I can confirm that you are now ready to make your first cartoon. This book has everything you need to get started in this industry. My advice is to follow all the tips I've given you.

Making a cartoon is easy when you know how it do. But that will not happen just by reading this book. You must take some time working on your skills. And even then, one cartoon is not enough. You will need to keep on making more frequently

Although you have heard this a million times, practice is what makes perfect. In fact, scientists have even proved that you must do something several times before it becomes second nature.

And when it becomes second nature, it means you are good at it.

Author Bio

Dr. Usman is an MD, now pursuing his post-graduation degree. As a medical doctor, he has deep insight in all aspects of health, fitness and nutrition.

He is a certified nutritionist and a personal trainer. With these qualifications, he has helped countless people reach their health, fitness and weight loss goals.

Dr. Usman is an avid researcher with 20+ publications in internationally accepted peer reviewed journals.

He is an accomplished writer with more than 5 years of writing experience. In this time, he has produced countless blogs, articles and research work on topics related to health, fitness and nutrition.

He is a published author with more than 100+ books published and several more in the pipe line.

Finally, he runs his own blog and posts health, fitness and nutrition related articles there regularly. You can visit his blog at http://hcures.com/

Check out some of the other JD-Biz Publishing books
[Gardening Series on Amazon](https://www.amazon.com)

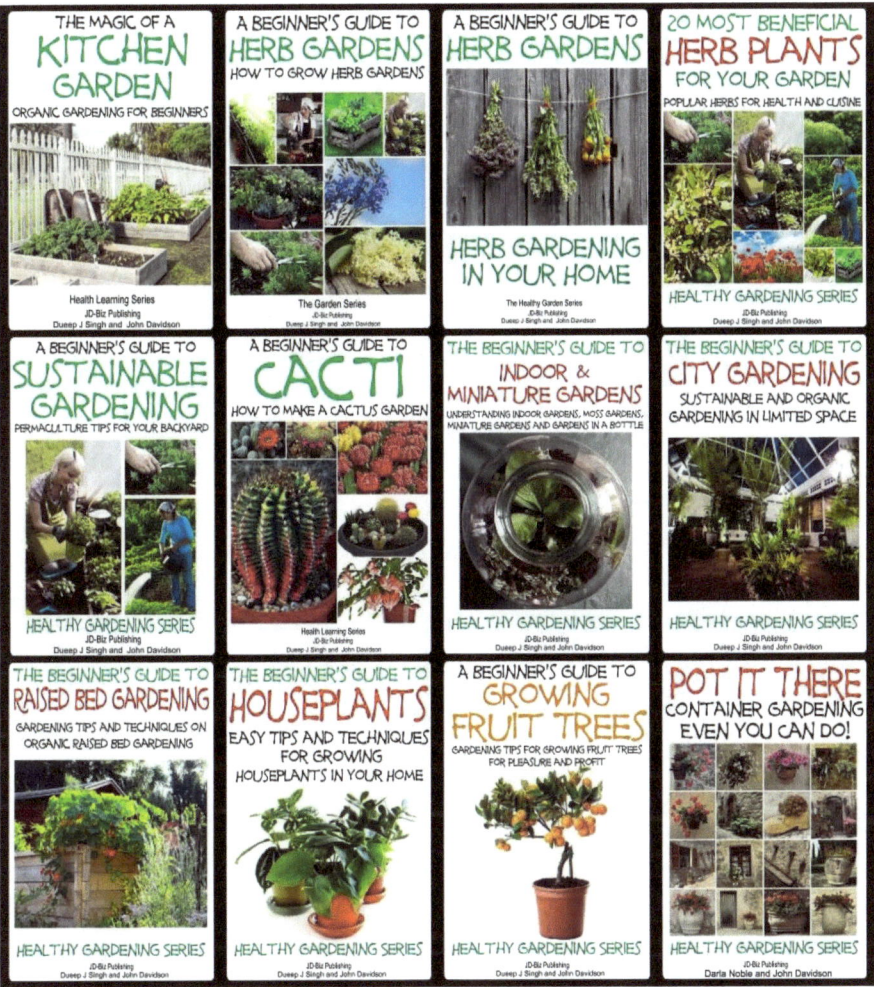

Download Free Books!
http://MendonCottageBooks.com

[Health Learning Series](#)

Country Life Books

Health Learning Series

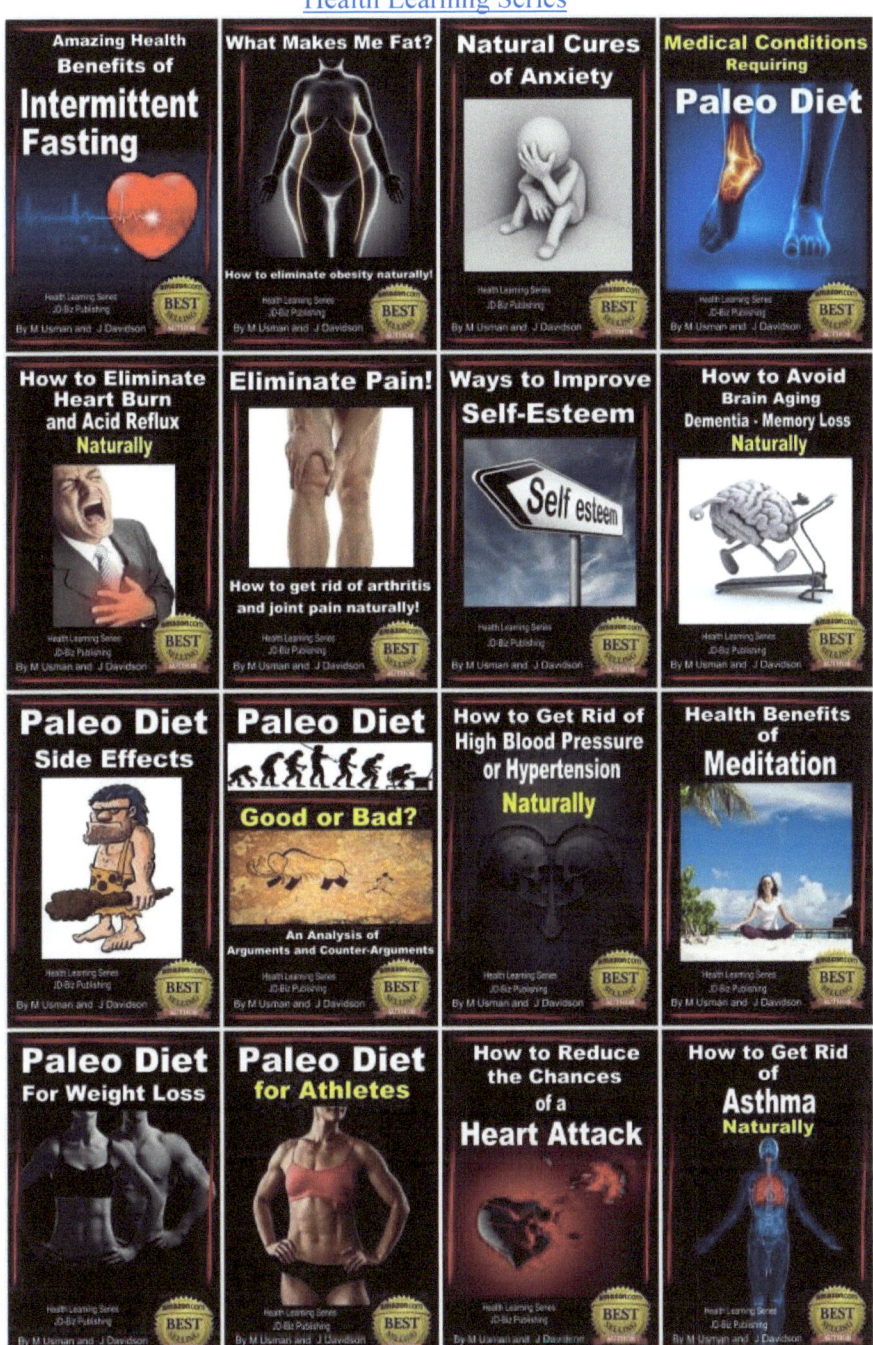

Amazing Animal Book Series

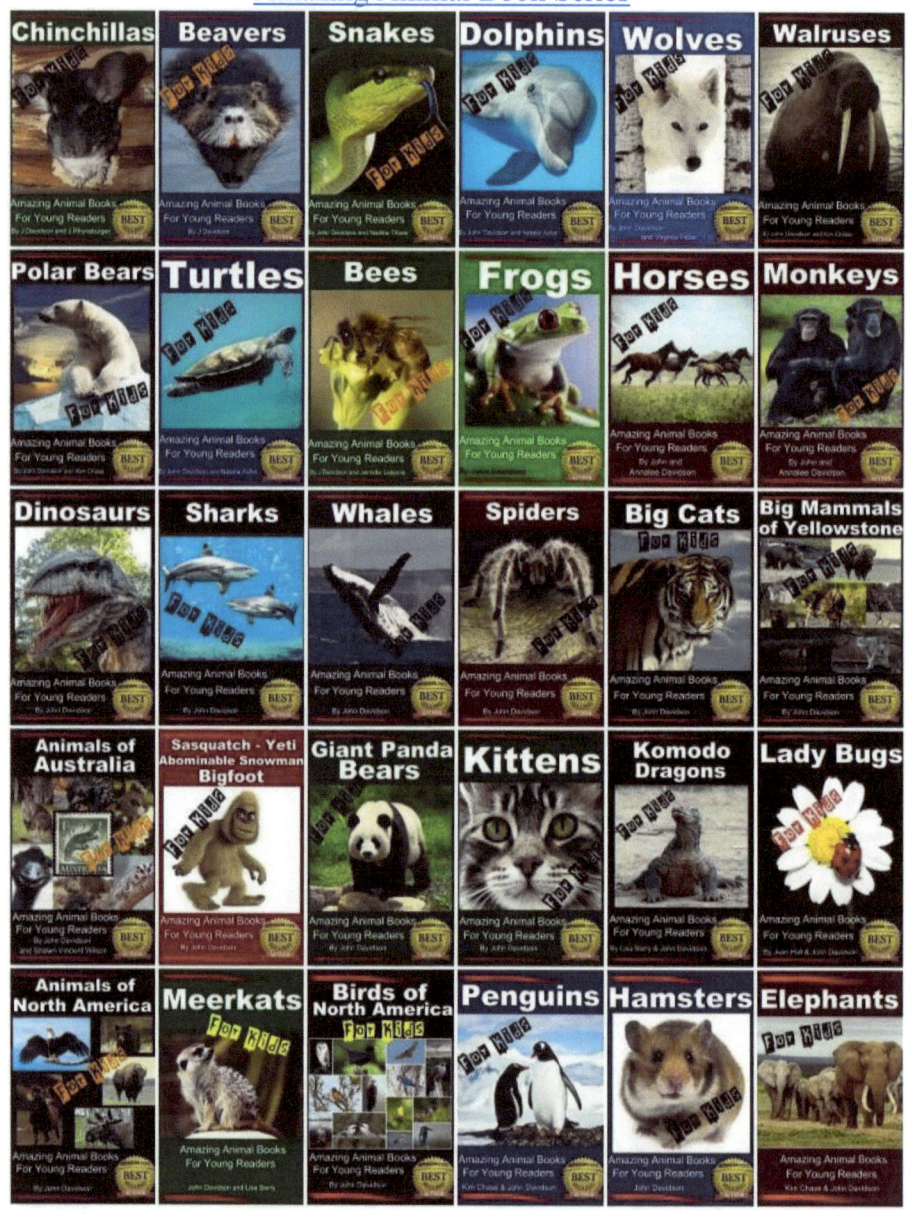

Learn To Draw Series

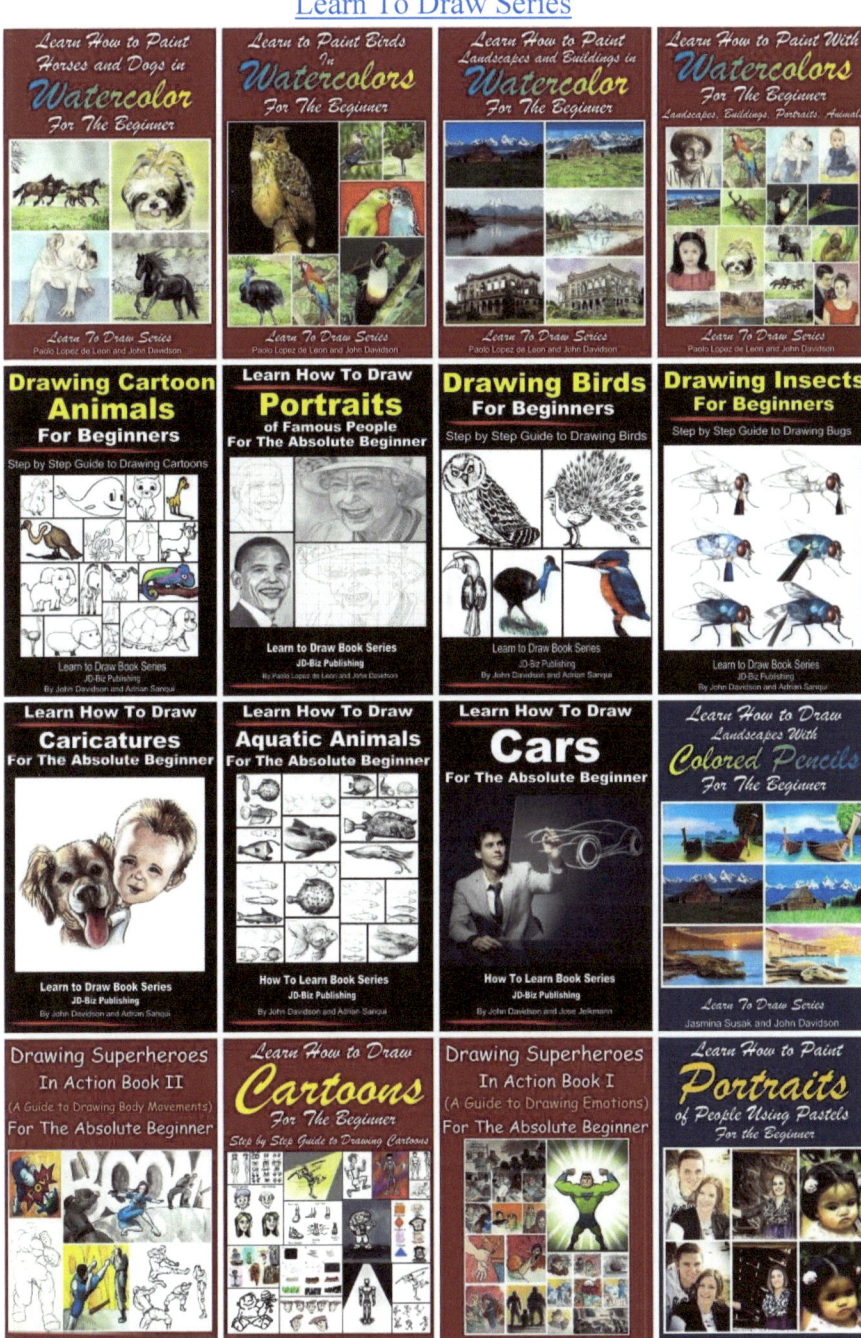

How to Build and Plan Books

[Entrepreneur Book Series](https://www.example.com)

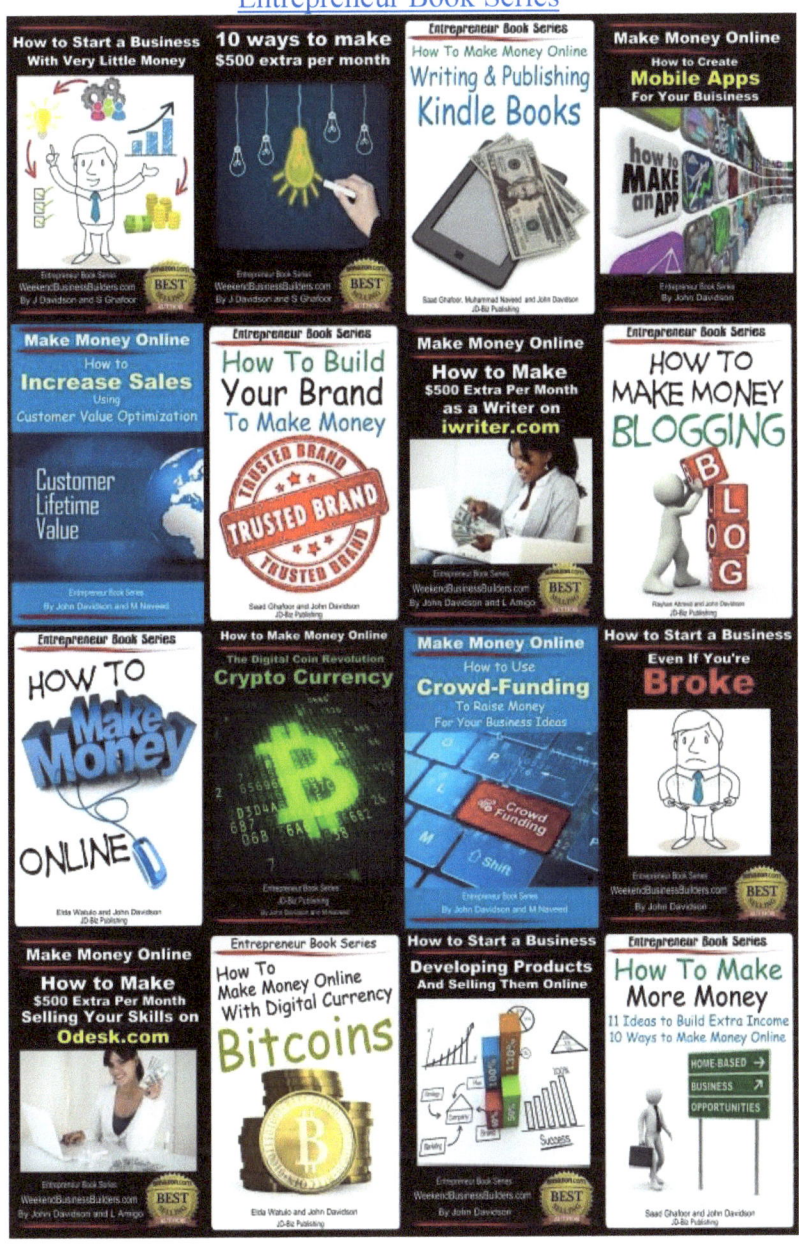

Our books are available at

1. Amazon.com

2. Barnes and Noble

3. Itunes

4. Kobo

5. Smashwords

6. Google Play Books

**Download Free Books!
http://MendonCottageBooks.com**

Publisher

JD-Biz Corp

P O Box 374

Mendon, Utah 84325

http://www.jd-biz.com/

www.ingramcontent.com/pod-product-compliance
Lightning Source LLC
Chambersburg PA
CBHW040924180526
45159CB00002BA/607